Thomas Kinkade

A Book of Joy

THOMAS KINKADE

A Book of Joy

**Andrews McMeel
Publishing**

Kansas City

ISBN: 0-7407-2230-1

Library of Congress Catalog Card Number: 2001095902

Compiled by Kathleen Blease

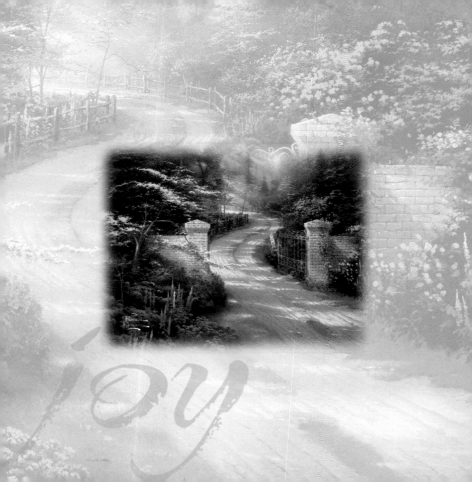

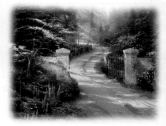

Everyday joys abound. It's a matter of perspective. For every trial there is a joy. For every loss there is a gain. Finding the benefits to typical challenges brings to focus the beauty of daily life. It's as simple as keeping what I call a joy journal, *jotting down the small gifts of being alive. The scent of a fresh breeze. The handshake of a*

friend. Sounds and sights. Aromas and textures. Life is a grand blessing, but it's one that is carefully made of tiny and simple joys. Just like a mural, it's pieced together stroke by stroke with the light and dark elements living together (one is never found without the other). A Book of Joy inspires us to open our eyes and hearts to these tiny but tangible building blocks that can create a world of celebration . . . and a life of possibilities.

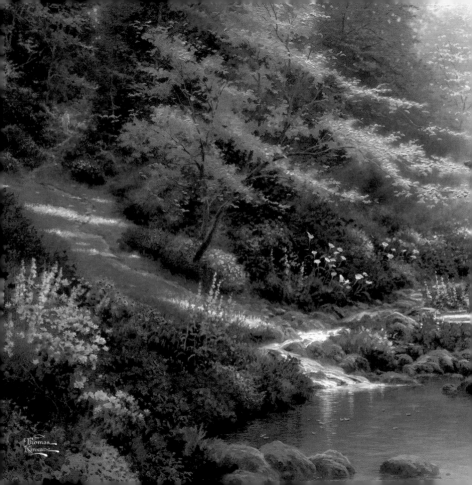

Beauty enters your heart through all the senses, and the beauty grows stronger when more than one of the senses is involved.

—Thomas Kinkade

*Keeping a glow book
or joy journal is something
I would highly recommend
if you find yourself a little rusty
at recognizing the joy gifts that come your way.*

—Thomas Kinkade

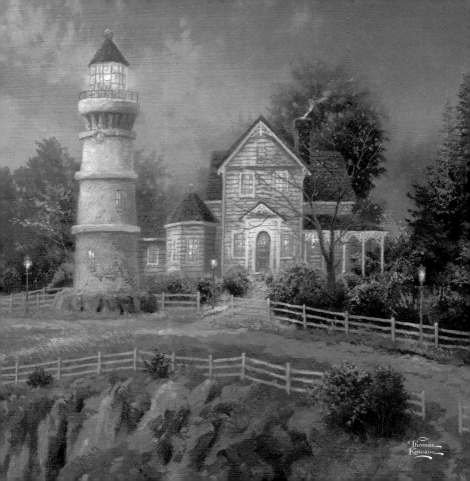

Close your eyes,
and picture a place
you're yearning to be.
A place that is beautiful
and comforting,
where everything
is hopeful and alive.

—Thomas Kinkade

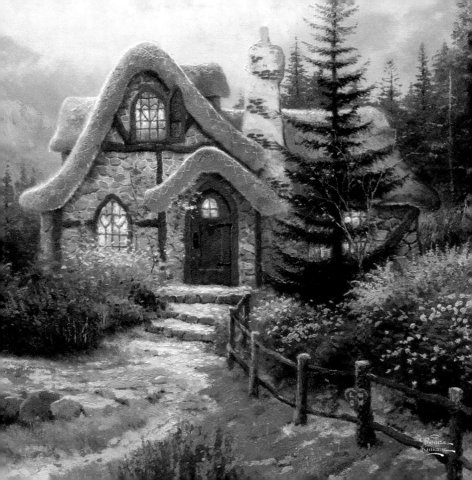

Thomas Kinkade

*Not many sounds in life,
and I include all urban
and all rural sounds,
exceed in interest
a knock at the door.*

—Charles Lamb

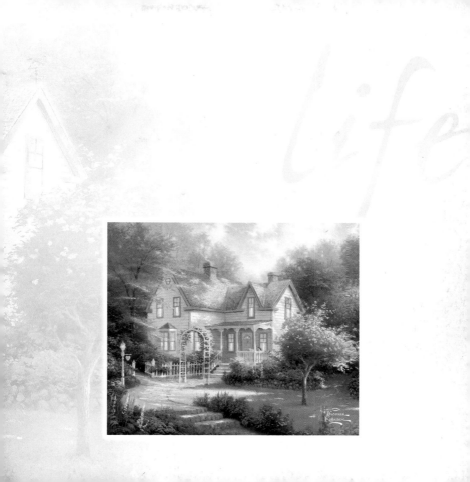

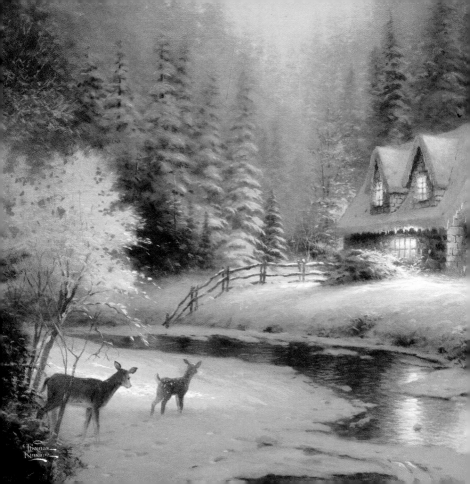

Harmony

is pure love,

for love

is complete agreement.

—Lope de Vega

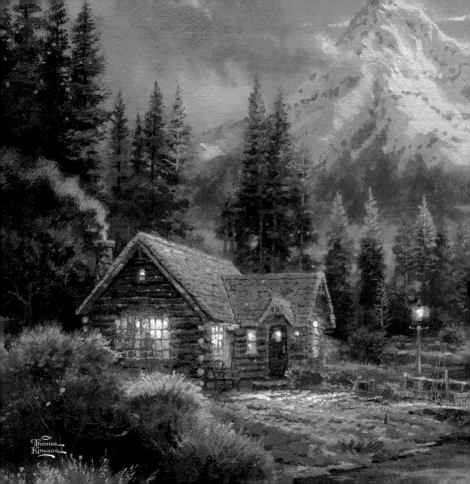

He that has light
within his own clear breast
may sit i' th' centre
and enjoy a bright day.

—John Milton

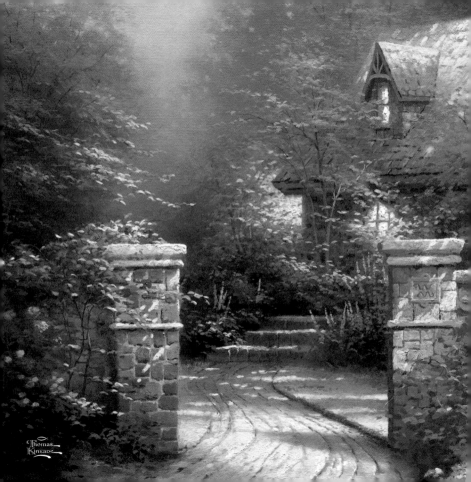

Consistent and durable joy
is generated
when we pursue a passion
that is strong enough
to carry us past pain,
something so meaningful
and absorbing
that we can ignore
unhappy circumstances.

—Thomas Kinkade

Our joys

as winged dreams

do fly.

—Anonymous

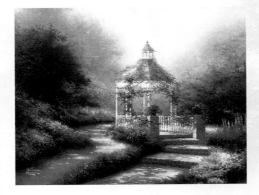

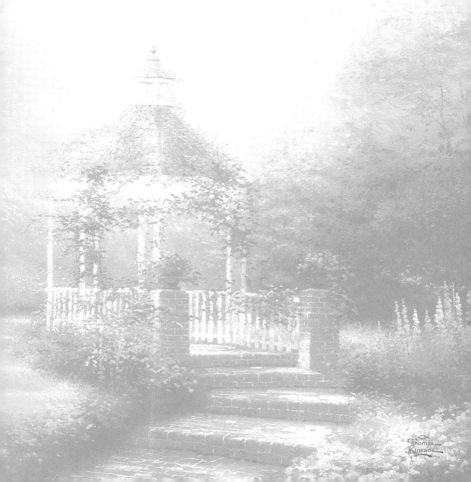

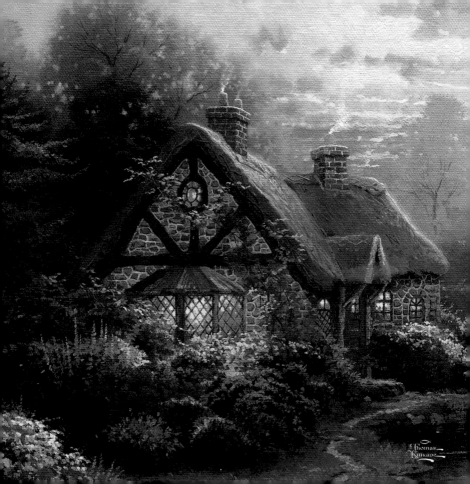

*Just as the body grows
and flourishes
on a healthy diet,
our joy can grow
and flourish
when fed a steady diet
of beauty.*

—Thomas Kinkade

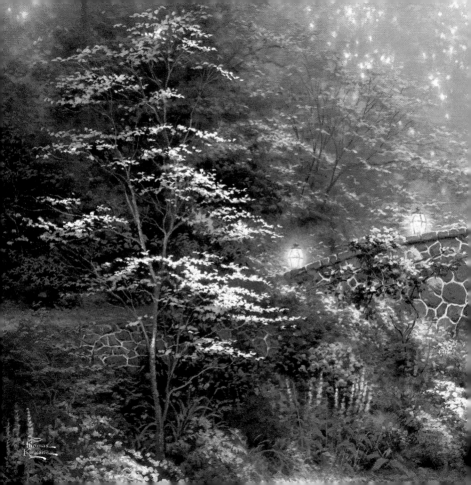

The supreme happiness

of life

is the conviction

that we are loved.

—Victor Hugo

The harvest

of a quiet eye.

—William Wordsworth

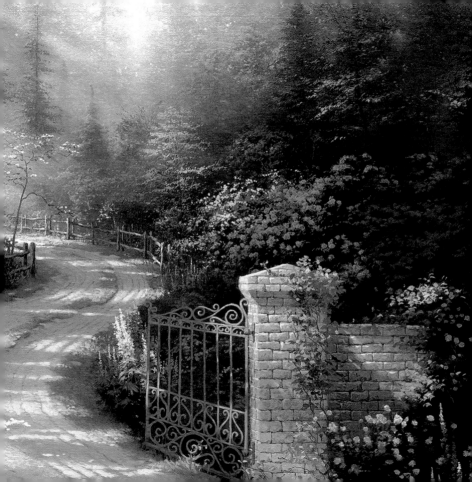

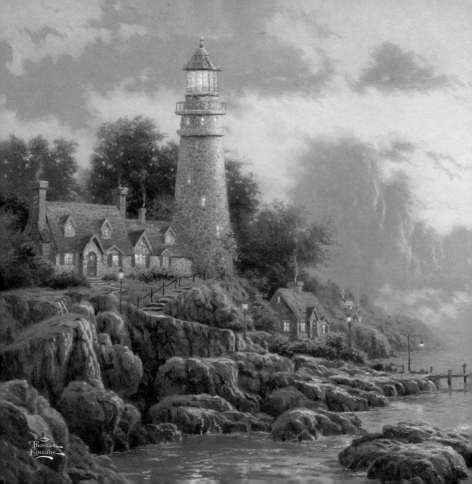

The first beauty
the world has to offer
is in nature.

— Thomas Kinkade

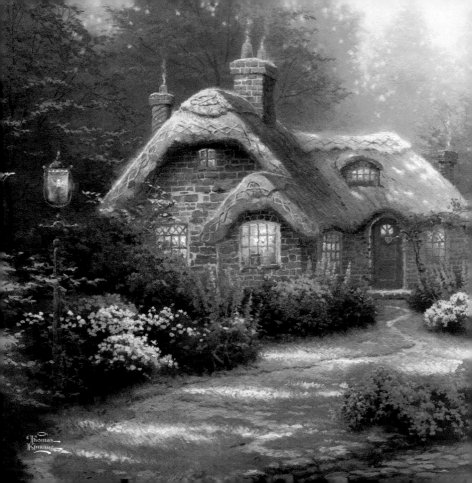

A Garden

is a lovesome thing!

—Thomas Edward Brown

beauty

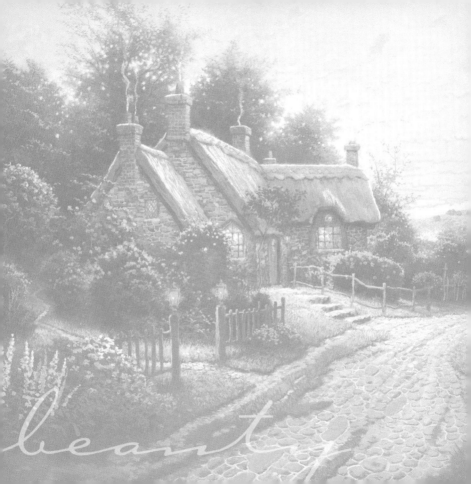

*Why is beauty so important?
Because we derive energy and
motivation from beautiful sights,
beautiful sounds, beautiful words
and ideas, and beautiful environments.*

—Thomas Kinkade

What a piece of work is a man!

how noble in reason! how infinite in faculty!

in form and moving how express and admirable!

in action how like an angel!

in apprehension how like a god!

the beauty of the world!

the paragon of animals!

—William Shakespeare

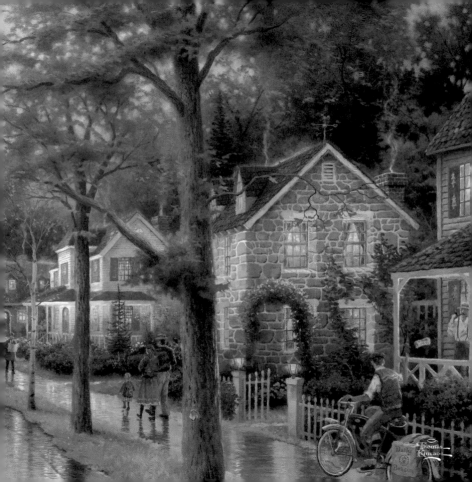

heart

Decide that joy is the hue

you want your heart to be.

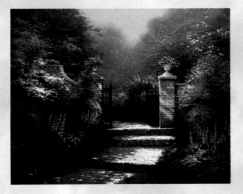

Then start making

the little and large choices that

over time will paint your heart happy.

—Thomas Kinkade

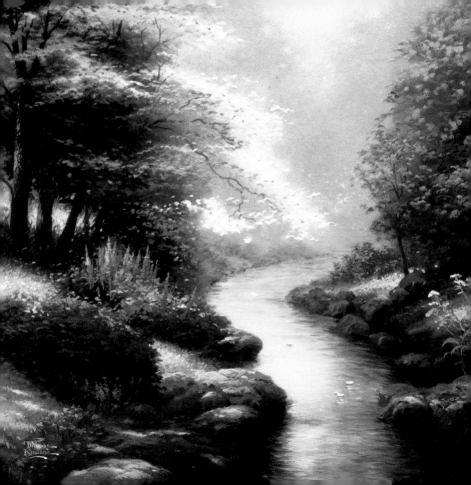

A thing of beauty is a joy forever;

Its loveliness increases; it will never

Pass into nothingness; but still will keep

A bower quiet for us, and a sleep

Full of sweet dreams,

and health, and quiet breathing.

—John Keats

For love is heaven,

and heaven is love.

—Sir Walter Scott

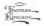

Give love,

and love to your life will flow,

A strength in your utmost need;

Have faith, and a score of hearts will show

Their faith in your work and deed.

— Madeline S. Bridges (aka Mary Ainge de Vere)

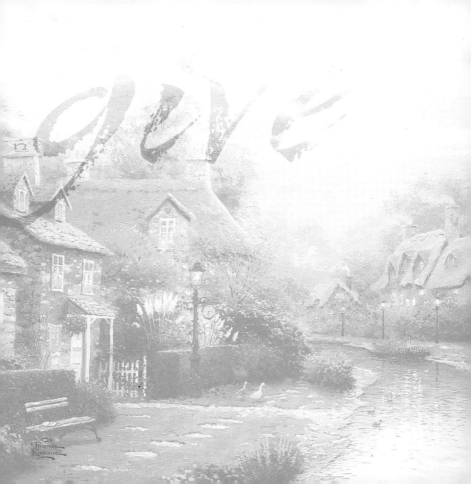

\mathcal{G}ive yourself a perk.

Condition yourself for joy

by doing little things

that you love on a regular basis.

—Thomas Kinkade

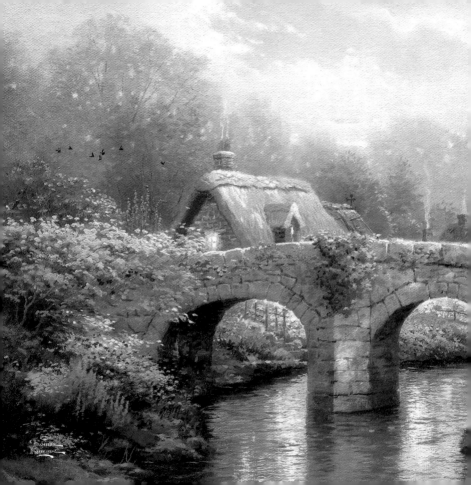

Surely goodness
and mercy
shall follow me
all the days of my life;
and I will dwell
in the house of the Lord
for ever.

—Psalms 23:6, King James version

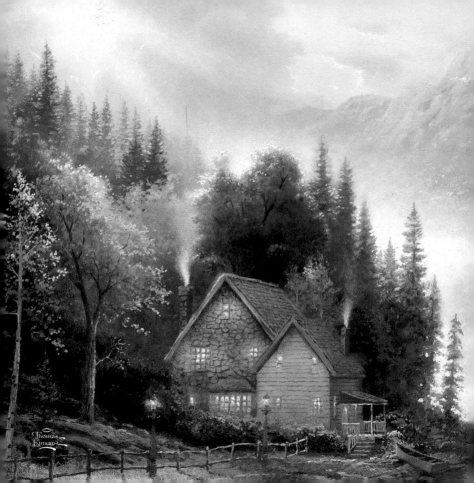

The art of being happy

lies in the power

of extracting happiness

from common things.

—Henry Ward Beecher

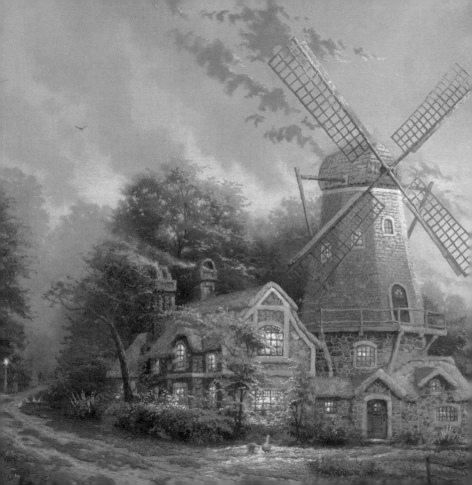

You don't **need** to travel

long distances to *revel*

in **natural** beauty.

All **you** have to *do*,

most of the **time**,

is go *outside*

and **look** at the sky.

— Thomas Kinkade

The greatest pleasure

I know

is to do a good action

by stealth

and have it found out

by accident.

—Charles Lamb

*O*nce you begin looking,
you may be surprised to discover
just how much joy
your world has to offer.

—Thomas Kinkade

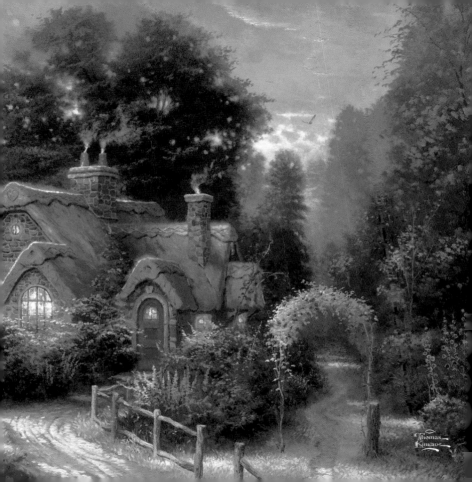

Thomas Kinkade

Grief

can take care of itself,

but to get the full value

of a joy

you must have somebody

to divide it with.

—Mark Twain

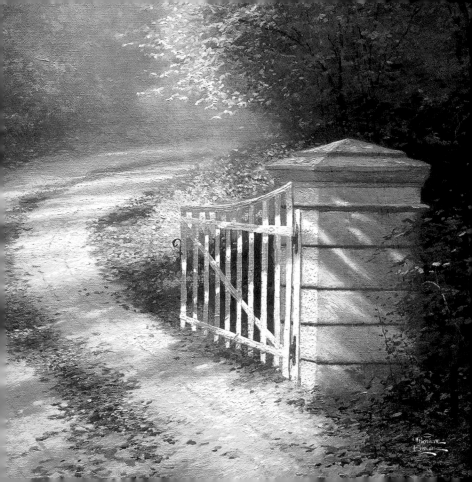

happiness

Growth itself

contains the germ of happiness.

—Pearl S. Buck

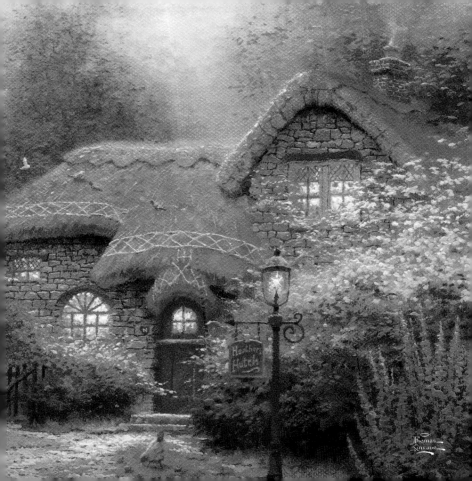

Happiness is a butterfly

which when pursued

is just out of grasp

But if you will

sit down quietly,

may alight upon you.

—Nathaniel Hawthorne

Happiness

is neither virtue

nor pleasure

nor this thing

nor that,

but simply growth.

We are happy when we are growing.

— William Butler Yeats

*Deep, abiding joy
is available to anyone
who learns the secret
of pursuing every task
with energy and dedication,
as though it were a calling.*

—Thomas Kinkade

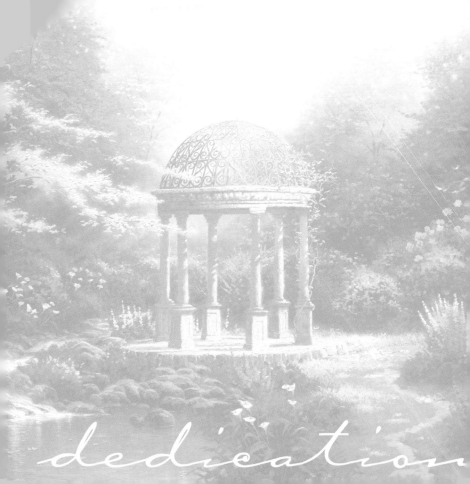

dedication

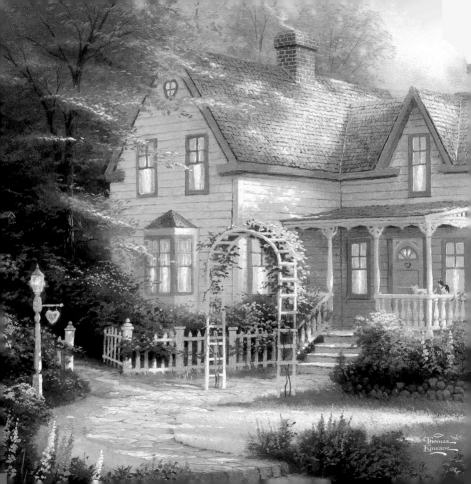

Happiness is the realization
of God in the heart.
Happiness is the result
of praise and thanksgiving,
of faith, of acceptance;
a quiet tranquil realization
of the love of God.

—White Eagle

First,

keep peace

within yourself,

then you can also

bring peace to others.

—Thomas à Kempis

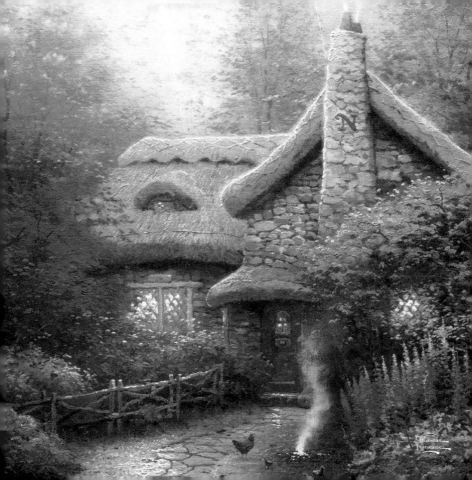

It really is possible
to color a dark canvas golden,
even with the tiniest of brushes.
You just keep on dabbing the paint,
and sooner or later you transform
the surface with brightness.

*In the same way,
if you keep on making joy choices,
small and large, your heart
will eventually display
a joyful tint that is more durable
than you ever imagined.*

— Thomas Kinkade

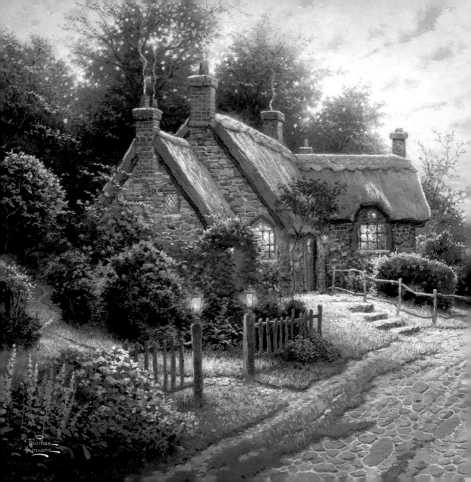

The happiness of life

is made up of minute fractions —

the little, soon-forgotten charities

of a kiss or smile,

a kind look

or heartfelt compliment.

—Samuel Taylor Coleridge

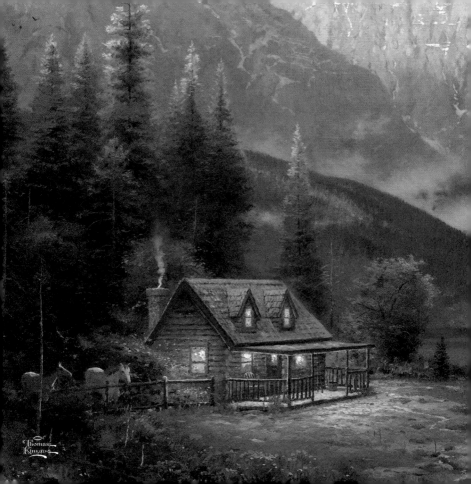

*If you want happiness
for an hour, take a nap.
If you want happiness
for a day, go fishing.
If you want happiness
for a year, inherit a fortune.
If you want happiness
for a lifetime, help somebody.*

—Chinese proverb

I've learned from experience that the greater part of our happiness or misery depends on our dispositions and not on our circumstances.

—Martha Washington

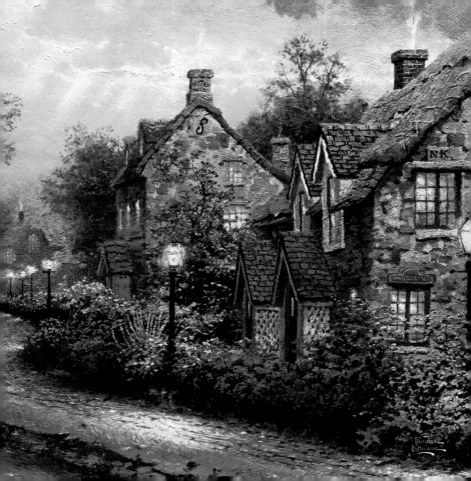

Joy is the happiness of love —

love aware of its own inner happiness.

*Pleasure comes from without,
and joy comes from within,
and it is, therefore,
within reach of everyone in the world.*

—Bishop Fulton J. Sheen

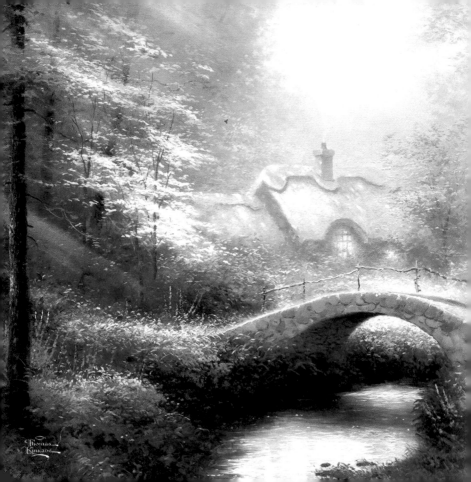

Many persons have a wrong idea
of what constitutes true happiness.
It is not attained
 through self-gratification
but through fidelity
 to a worthy purpose.

— Helen Keller

May there always be work
for your hands to do,
May your purse always hold a coin or two.
May the sun always shine
warm on your windowpane,
May a rainbow be certain to follow each rain.
May the hand of a friend always be near you,
And may God fill your heart
with gladness to cheer you.

—Anonymous

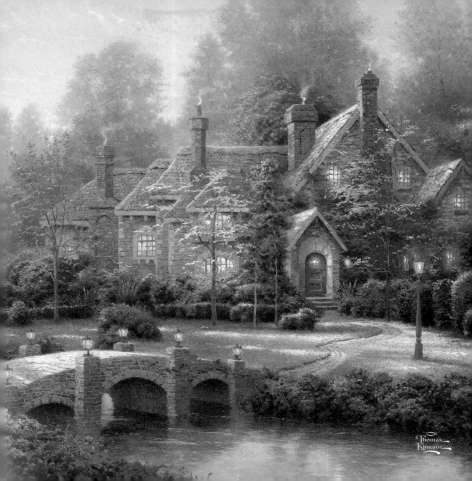
Thomas Kinkade

Somehow not only for Christmas
But all the long year through,
The joy that you give to others
Is the joy that comes back to you.

And the more you spend in blessing
The poor and lonely and sad,
The more of your heart's possessing
Returns to make you glad.

—John Greenleaf Whittier

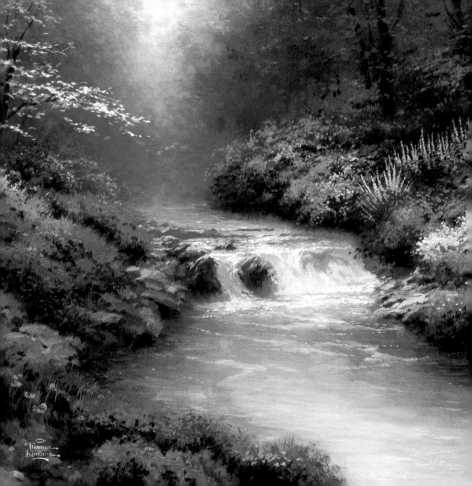

The sun does not shine

for a few trees and flowers,

but for the wide world's joy.

—Henry Ward Beecher

*There is no value in life
except what you choose
to place upon it
and no happiness in any place
except what you
bring to it yourself.*

—Henry David Thoreau

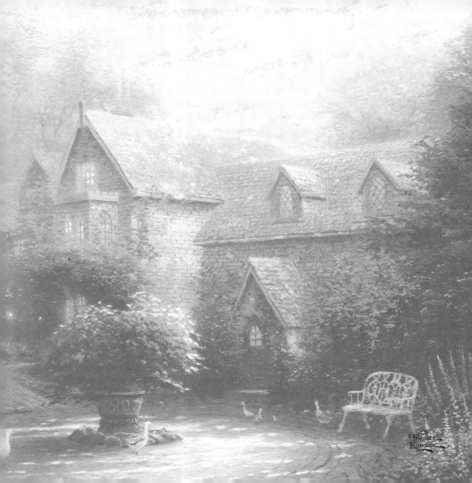

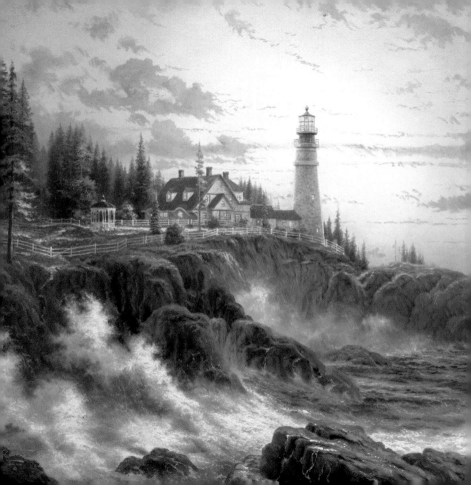

*There is only one way
to happiness and that is
to cease worrying about things
which are beyond
the power of our will.*

—Epictetus

Twenty years from now
you will be more disappointed
by the things that you didn't do
than the ones you did do.

sail away

So throw off the bowlines.
Sail away from the harbor.
Catch the trade winds in your sails.
Explore. Dream. Discover.

—Mark Twain

*To strive with difficulties,
and to conquer them,
is the highest human felicity.*

—Samuel Johnson